Phillip Allen

Foreword

This is the first solo exhibition by the artist Phillip Allen in a British public gallery and brings together a selection of work from over a five-year period.

Compelling and continually inventive, Phillip Allen is an original and distinguished voice in contemporary British art. He is known for his distinctive paintings, predominantly oil on board, in which the bottom and top edges are encrusted with a thick, globular application of paint. Such is the impastoed thickness, that the very paint itself seems to cling to the support, evoking a certain tension and an evident vulnerability.

Allen's preoccupation with the visual 'margins' – physically and conceptually transgressing the rectangular boundaries of the painting – seems to subvert the traditional hierarchy of how we read the picture plane – a 'distraction' maybe, so as not to deal with the act of painting itself. At first, his seemingly subconscious, impulsive and doodle-like compositions compound this view but belie his almost conventional process, as the paintings, particularly the central sections, are borne from Allen's tireless studies with felt-tip pen on A4 paper. Once more, his wondrously inventive titles; *Beezerspline*, *Stutterscape* and *Nollet* to name but a few, speak of a playful yet purposeful intent. Allen's practice both engages and rebuffs the formal ideals of modernism, bringing together 'painting as a process' with a warm embrace of illusionism. His business is the 'business of painting' and throughout, his enigmatic work; beautiful and ugly, abstract and illusionistic, modest and profound, asks as many questions as it answers.

This exhibition and catalogue has been made possible with the generous support and assistance of many people. In particular I would like to thank Caoimhín Mac Giolla Léith for his timely and revealing essay. We are grateful to all those collectors who have generously loaned their work for the purpose of the exhibition and to Kerlin Gallery, Dublin and Xavier Hufkens, Brussels for their administrative assistance and support of this publication. In particular I would like to thank Jake Miller of The Approach, London for his time and commitment to both the exhibition and the catalogue. And as ever, a special thank you to the artist Phillip Allen.

Michael Stanley
Director, Milton Keynes Gallery

Painting and Contradiction

Like the classical image of Antaeus and Hercules locked in a strenuous embrace, the one drawing strength from the earth and the other with an eye to the heavens, a painting by Phillip Allen presents the viewer with a self-contained drama of seemingly irreconcilable opposites. Each individual work stages a face-off between matter and metamorphosis, between paint as base materiality and painting as imaginative transformation. Confronted with one of his pictures we may find our gaze shifting back and forth between a place where nothing can move and a space in which anything can happen, between heavily impastoed passages of oil paint squeezed straight from the tube, which push out into the viewer's visual and physical ambit, and a flatter field of thinly applied paint that pulls our eye into a space of considerable illusionistic depth. Clotted swirls, thick cords or congealed smears of raw paint form horizontal bands along the top and bottom of each painting, all of which are painted on solid board rather than stretched canvas. Sometimes these borders are narrow fringes clinging to the edge of the picture plane. Sometimes they are lava-like viscosities that threaten to engulf it. Occasionally they have been scraped away almost entirely leaving just a faint memory of earlier encrustations. Suspended between the dark and dense materiality of these upper and lower bands is a more expansive, luminous field, often irradiated by shafts of painted light emanating from a distant vanishing point or points. This is an arena within which a kaleidoscopic array of brightly coloured geometric, biomorphic, architectonic or numeric motifs are free to play. The complex concatenations of vivid shapes that inhabit this middle ground have their origins in a swarm of small felt-tip drawings, which seems to be constantly expanding across the walls of Allen's modest studio. During the painting process, which proceeds at a greater speed than one might imagine, these germinal compositional elements acquire a life of their own, combining and mutating in largely unpremeditated ways as this area of the painting is elaborated. In contrast, the agglutinating gobbets of raw paint that hem this arena in, some of which will take months to dry and stabilize completely, imply a far slower tempo, something more akin to geological time. The obvious resemblance of these viscid outer limits to dollops of raw paint on a traditional palette tend to relate them, in the viewer's mind if not the viewer's eye, to the prehistory of the painterly act proper, a time before compositional creativity took flight.

The preponderance of earthen tones in the lower borders in particular, as well as a general preference for horizontal over vertical formats, encourage a reading of these enigmatic pictures as hallucinatory landscapes or virtual skyscapes, often replete with painterly incident, but sometimes quite sparing, though never remotely austere. Given the relatively constrained and consistent format to which all of these paintings adhere, it is remarkable how disparate a range of visual domains they conspire to evoke, though they do so quite obliquely. A brief list might include the virtual universe of

computer games, the scenography of science fiction, the fantasy architecture of the fairground, the microscopic world of atoms and molecules, the refracted optical displays of rainbows and sunbursts, and the richly decorative patterning of Islamic art and architecture. To invoke these domains, however, is to risk a reductive and overliteralising reading of a painting practice whose internal formal dynamics function quite independently of this range of references. Besides, such references are as readily suggested by the work of many other contemporary painters with whom Allen has little in common. In fact his work betrays few obvious affinities with that of painters from his own generation and immediate milieu. At a stretch, one might note glancing resemblances to certain aspects of the work of a number of continental European painters of different generations and cultural provenance, from Raoul de Keyser to Tal R. At a further stretch, the exploding shafts of grey-white light that illuminate the *Beezerspline* paintings (2002) and *The Falestorm (Avoidance Version)* (2002), as well as several other works, distantly recall Jay DeFeo's gargantuan, one-ton mandala *The Rose*, a painting that occupied this Californian visionary almost exclusively from 1958 to 1965. Allen's work, however, steadfastly maintains a link with Old World easel painting that would have been incompatible with DeFeo's monumental labours. A more thoroughgoing comparison, if one were required, might be drawn between Allen's distinctive sensibility, a peculiar blend of colouristic extravagance and quietism, and that of a painter like Thomas Nozkowski who has, for over thirty years, been patiently mining a vein of idiosyncratic abstraction, with occasional reference to the landscape, that has gradually secured him a reputation as a classic painter's painter in a New York art world more instantly responsive to billboard-scaled bravado.

Contradiction, as has already been suggested, is crucial to the paintings of Phillip Allen. The teetering archways and shaky or exploding edifices, the torqued molecular strings and swirling starbursts, the heaped cairns and incongruously reified numerals, the dancing blobs and floating balloons jostle, clash and overlap in a frequently crowded pictorial field that seems barely able to contain itself, were it not for the limitations imposed on it by the palpable physicality of its upper and lower borders. Yet both within and beyond this rich synaesthesic mix of the visual and the haptic, of fizzing colour and coagulating pigment, there is one notable ingredient that functions as a kind of thematic brake against any tendency toward painterly cacophony. It is an aspect of Allen's work that paradoxically speaks of silence, lack or even failure. This ingredient is linguistic. The sad inadequacy or comical superfluousness of descriptive language in the face of the most self-sufficient forms of abstraction is registered in Allen's works on two distinct levels, one extrinsic to the paintings and one intrinsic to them. The first is that of nomenclature. *Beezerspline, Enaclite, Katterfelto, Nollet, Ponananko, Densequalia*. An admittedly selective list of titles, drawn from his output over the past five years, reads like an imaginary lexicon of exotic and meaningless words; waiting, perhaps, to be pressed into service by some latter-day Lewis Carroll or Edward Lear. The rhythmic delight of nonsense verse to the adult ear derives no

doubt in some part from a deep-seated, childish memory of the exuberant pleasures of prelinguistic play unadulterated as yet by the dictates of sense or semantics. Allen's ludic titles often look and sound like they might mean something, but stop short of actually doing so, suggesting that the rich sensorial world conjured by his paintings is one in which language will be forever confounded. *Stutterscape*, the title of a small painting from 2003, hints at one reason why this might be so. The artist is understandably reluctant to overstress the significance within his work of a speech impediment that nonetheless must colour to some degree his social interaction with those around him. Yet one of the more insistently recurring motifs in his paintings is the blank comic book speech-bubble. These invariably empty shapes, bereft of the words we conventionally expect to be contained within them, are more often than not painted black. This motif features prominently in a procession of paintings that includes *Achievement and Retention* (2002), *Deep Level Sequence (Obscurantist Version)* (2003), *Second Ace Worry (International Version)* (2004) and *Shallow Level Sequence (Studio Version III)* (2004). These darkened repositories for cancelled speech acts never appear in isolation, tending rather to proliferate with mute abandon. They attach themselves in great numbers, and what looks like regular botanical formation, to black plant-like stems that reach for the sky and threaten to blot out the light; or they are pulled on dark slender threads into or out from an invisible faraway vortex; or else they appear to be simply floating away into some distant silence. Speechless foils trapped within a vision of otherwise florid display, these graphic emblems of inarticulacy act as a sort of *repoussoir*, in a manner comparable to that of the roughly textured borders, effectively tempering any chromatic or compositional extravagance and slowing down the pulse of those paintings in which they appear. Compared to those classic forms of late modernist abstraction that, according to their most authoritative exegetes, depend on the seemingly instantaneous availability to the viewer of the whole work in all of its aspects, a painting by Phillip Allen solicits our gaze by incremental degrees and in contrasting ways. To characterise them, however perversely, in hoary terms familiar from another age, these paintings rely on duration and any notion of flatness in them is pretty relative. The title of a relatively large work from 2001, *Little Moments of Small Joy (Gallery Version)*, may seem unduly modest, if not misleading. Yet it has the benefit of giving some indication of that sense of dispersal, protraction and inherent, structural contradiction that is one of the defining characteristics of Allen's art. The more optically exuberant of these paintings may seem designed to instantly attract the viewer's eye. They certainly stand out and command attention. But Allen's paintings are by no means showy, and they take some time to see.

Caoimhín Mac Giolla Léith

Little Moments of Small Joy (Gallery Version) 2001

Oil on board 152 × 122 cm

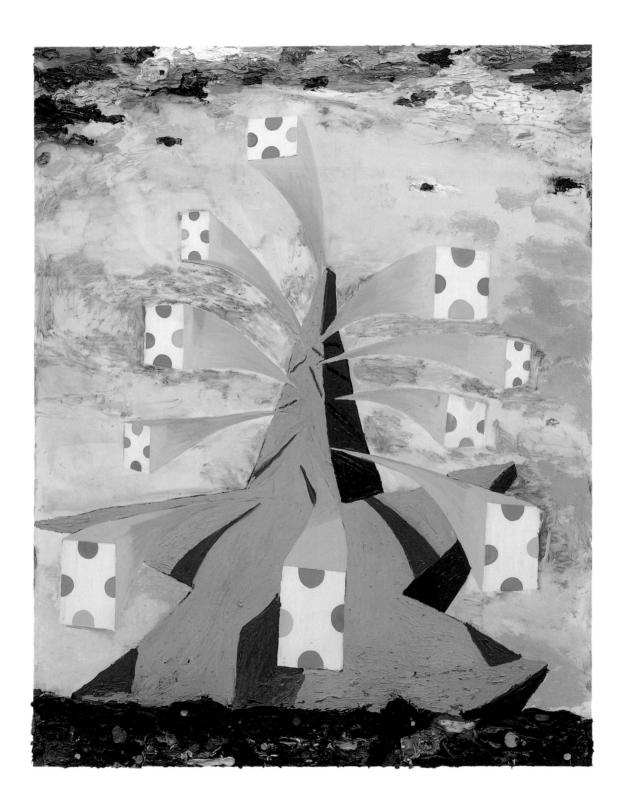

33 (Extended Version) 2001

Oil on board 40.5 × 51 cm

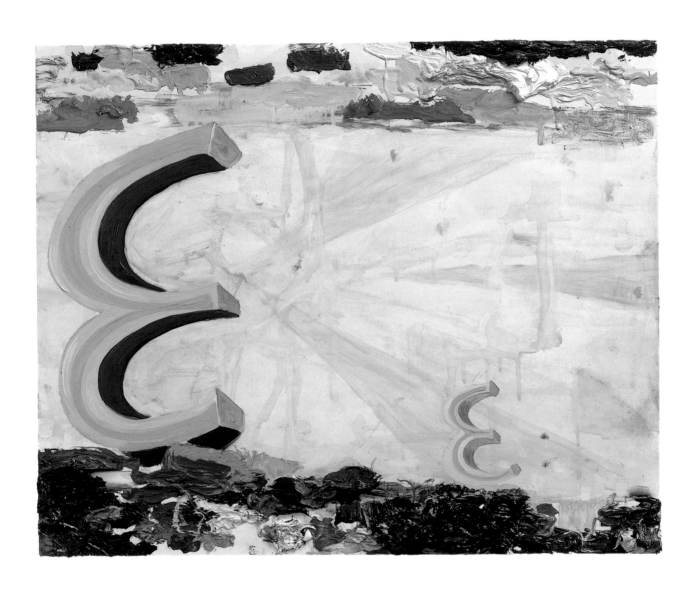

Beezerspline (Studio Version) 2002

Oil on board 30.5 × 40.5 cm

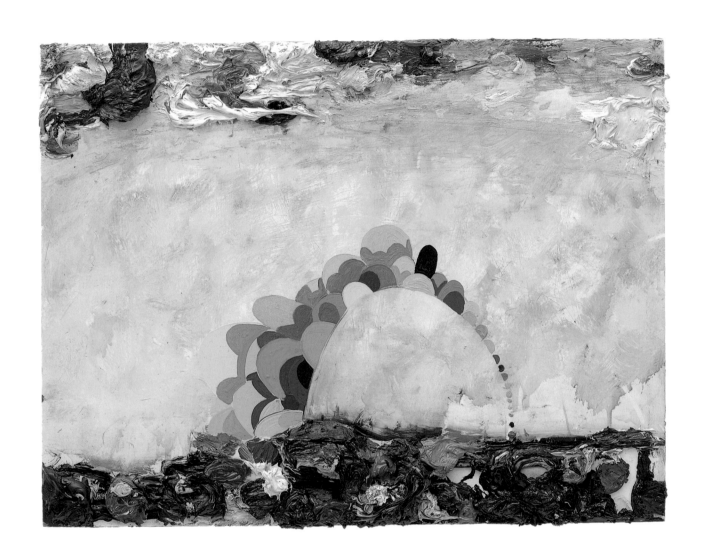

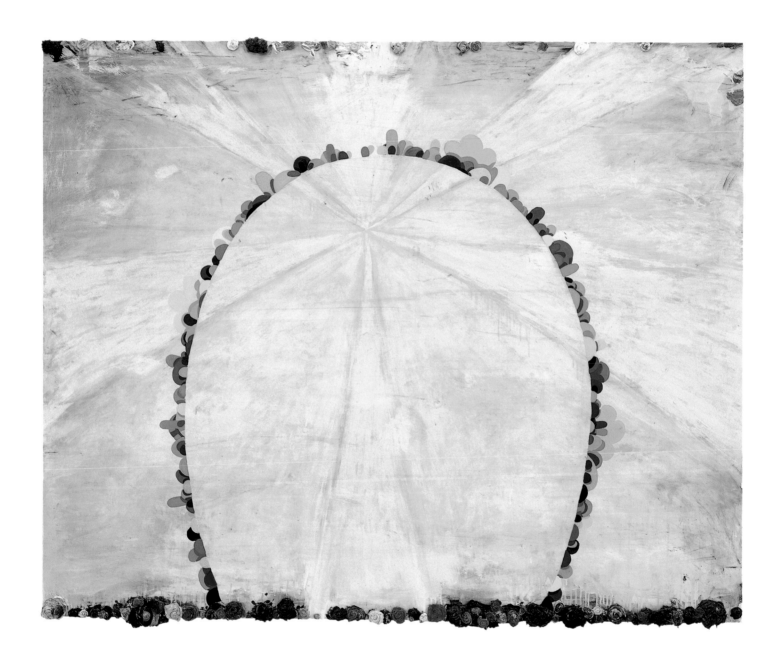

Beezerspline (Light Version) 2002

Oil on board 122 × 152 cm

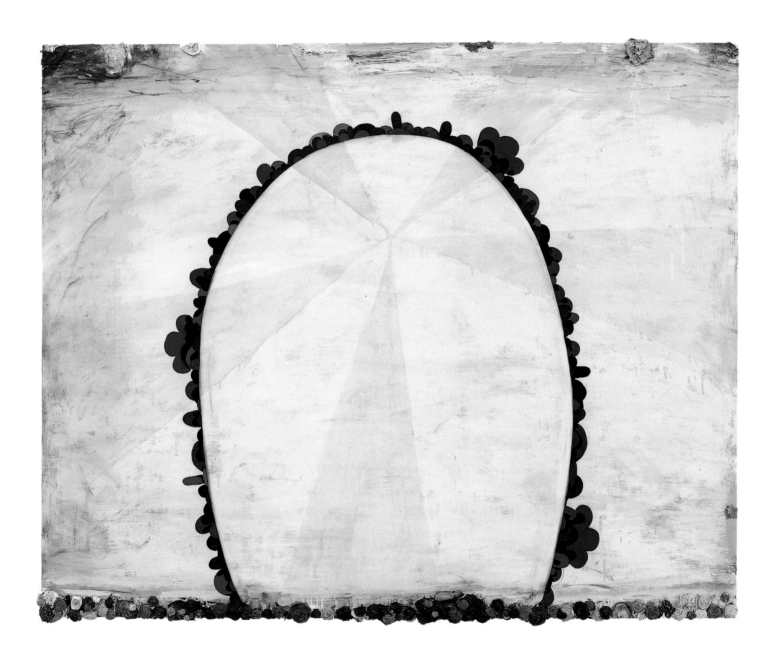

Beezerspline (Dark Version) 2002

Oil on board 122 × 152 cm

International 2002

Oil on board 56 × 71 cm

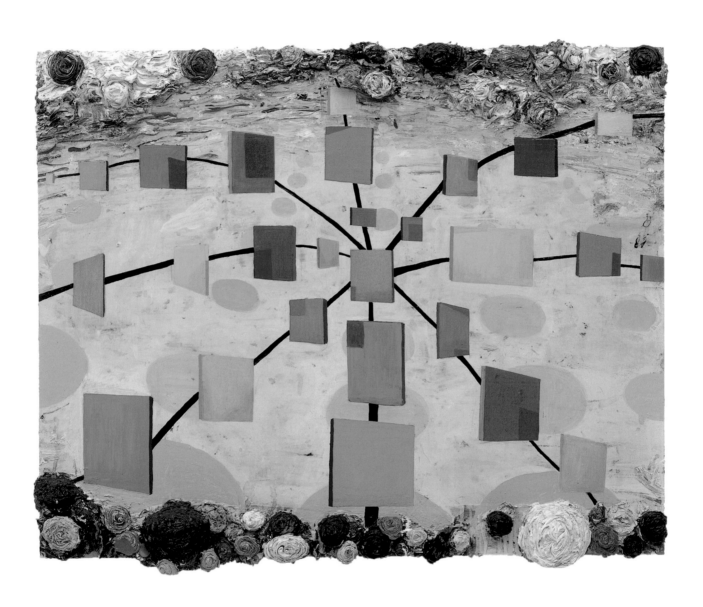

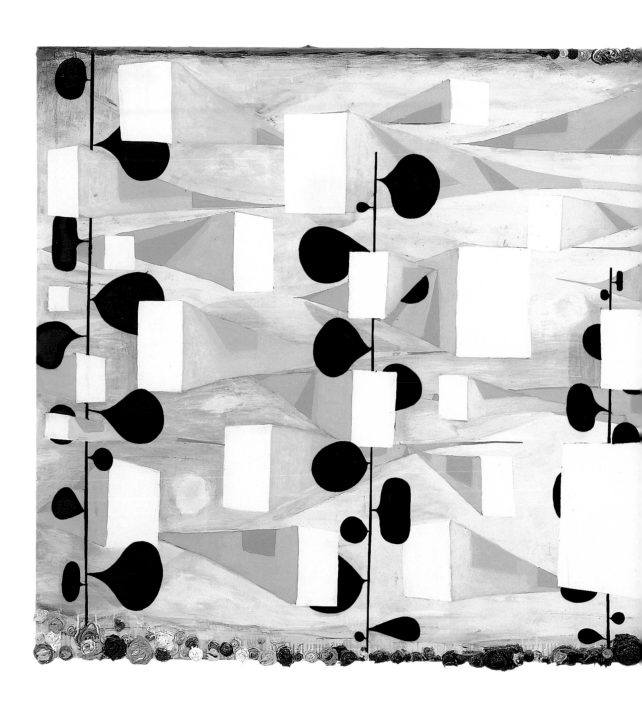

Achievement and Retention 2002

Oil on board diptych 112 × 244 cm

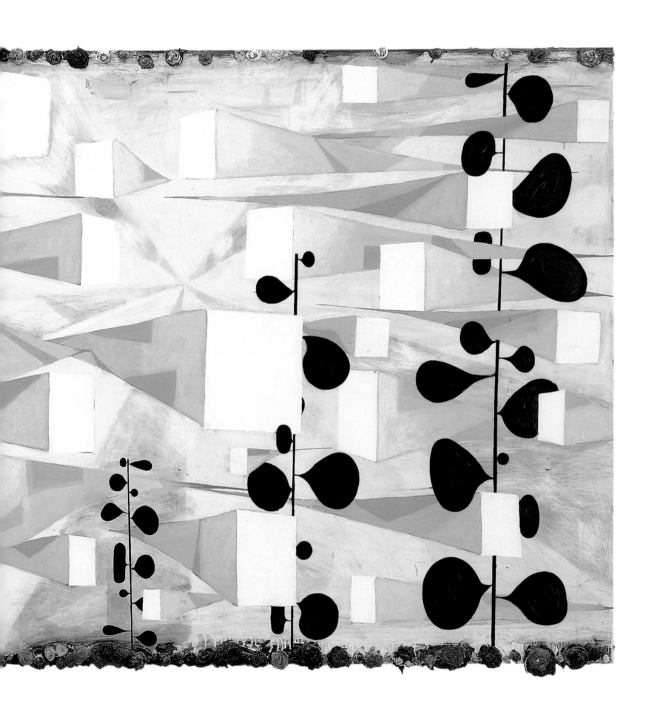

Slinky Salvo 2003
Oil on board 60 × 80 cm

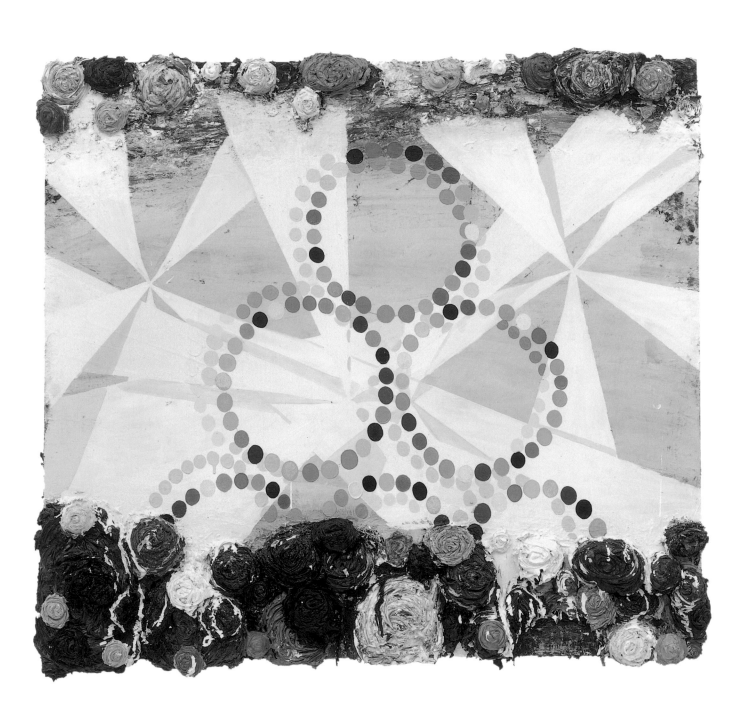

Enaclite (Digitally Enhanced Version) 2003

Oil on board 122 × 152 cm

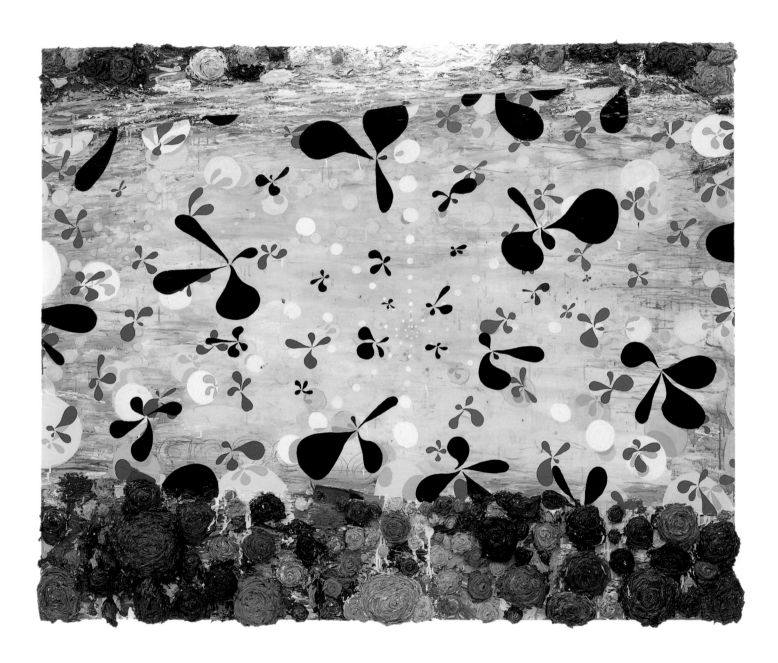

International (Nullo Version) 2003

Oil on board 56 × 71 cm

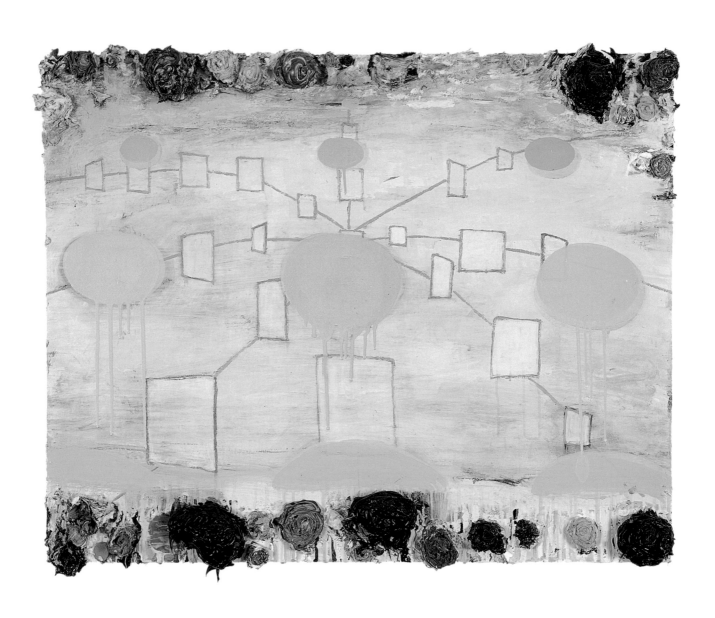

Stutterscape 2003

Oil on board 58 × 71 cm

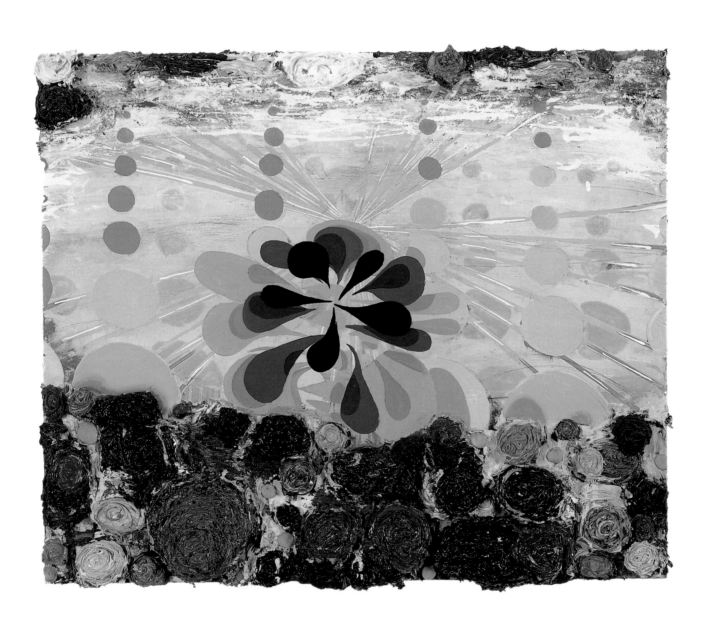

Deep Level Sequence (Obscurantist Version) 2003

Oil on board 122 × 152 cm

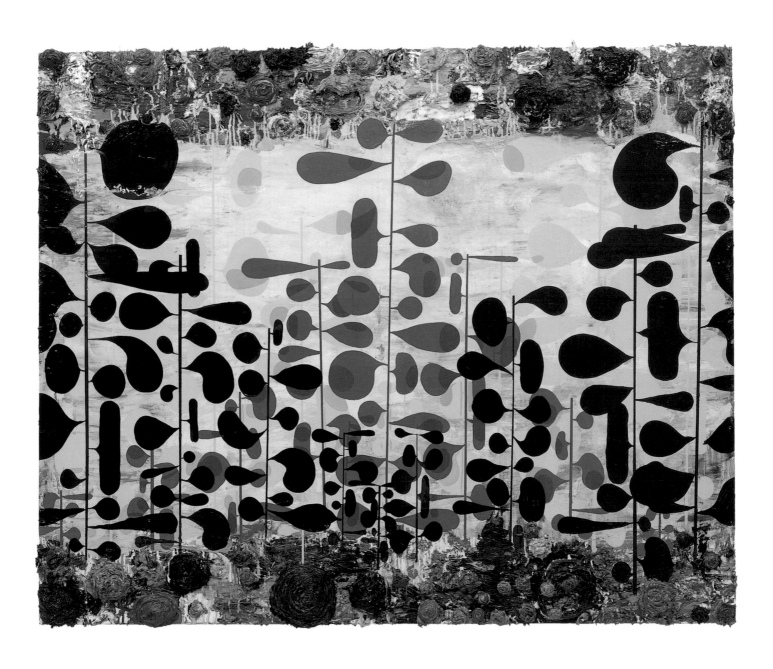

Tedious Plan 2004

Oil on board 122 × 152 cm

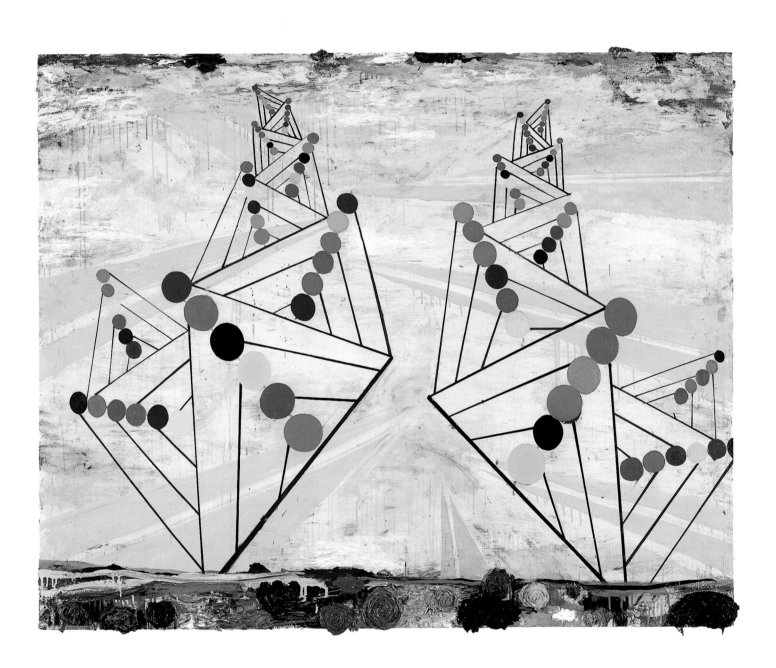

Second Ace Worry (International Version) 2004

Oil on board 152 × 122 cm

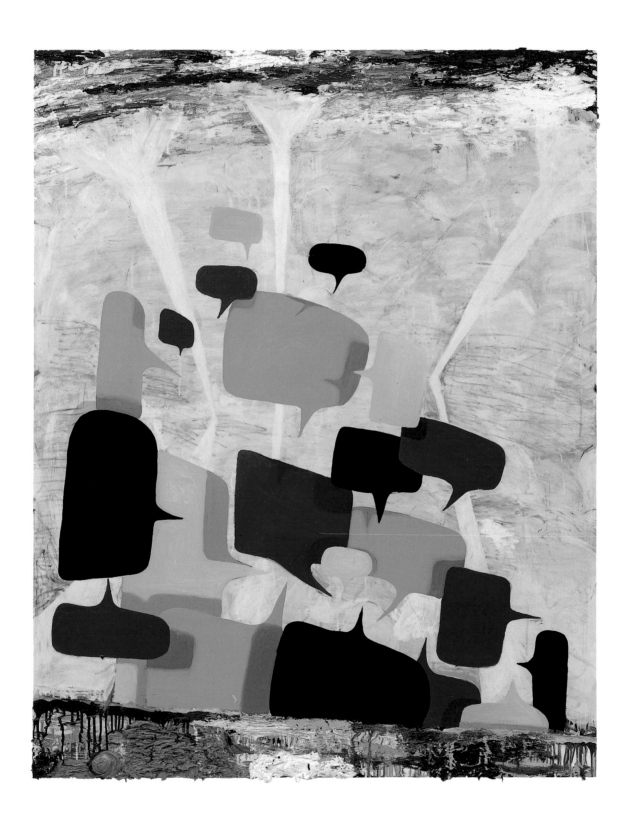

Dynamic Mobility (Academy Version) 2004

Oil on board 122 × 153 cm

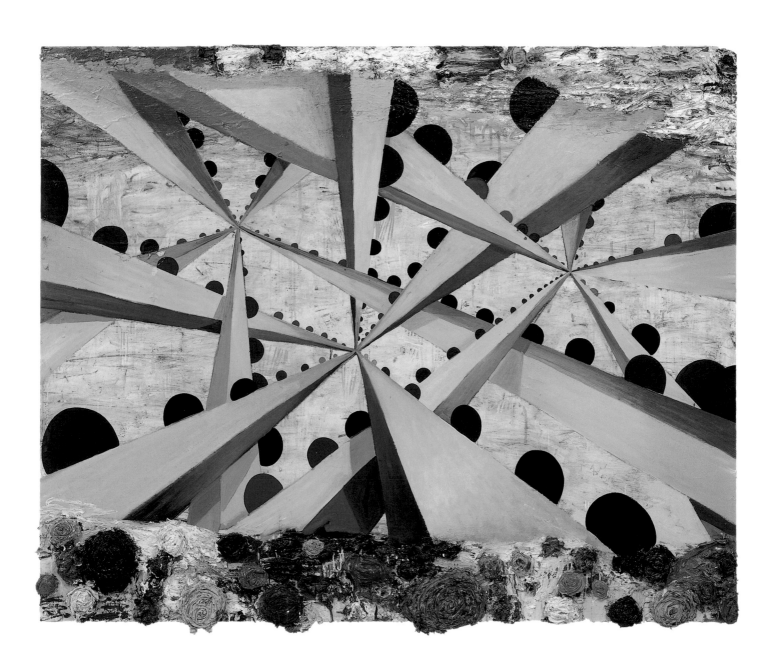

Shallow Level Sequence (Indian Defence Version) 2004

Oil on board 77 × 91 cm

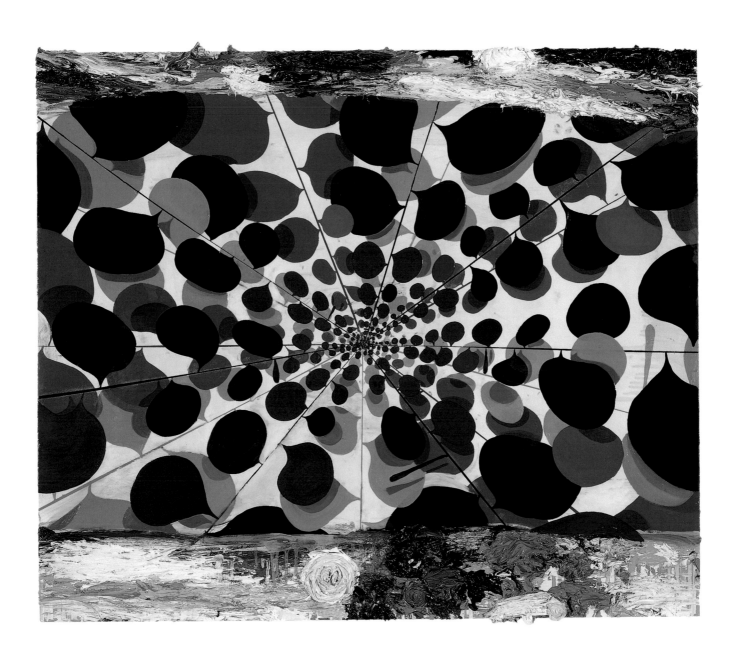

Contacts and Beliefs (Academy Version) 2004

Oil on board 122 × 152 cm

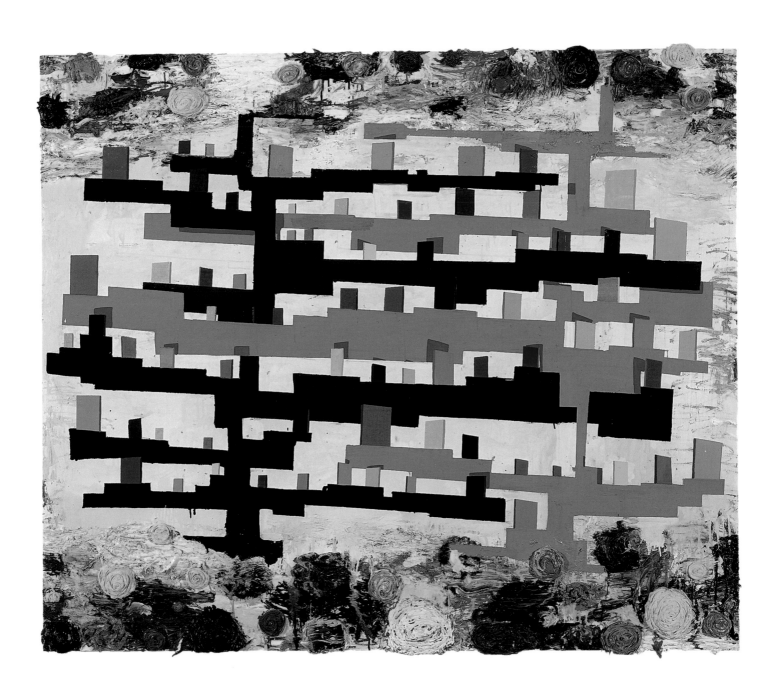

Katterfelto (Early Promise Version) 2005

Oil on board 77 × 91 cm

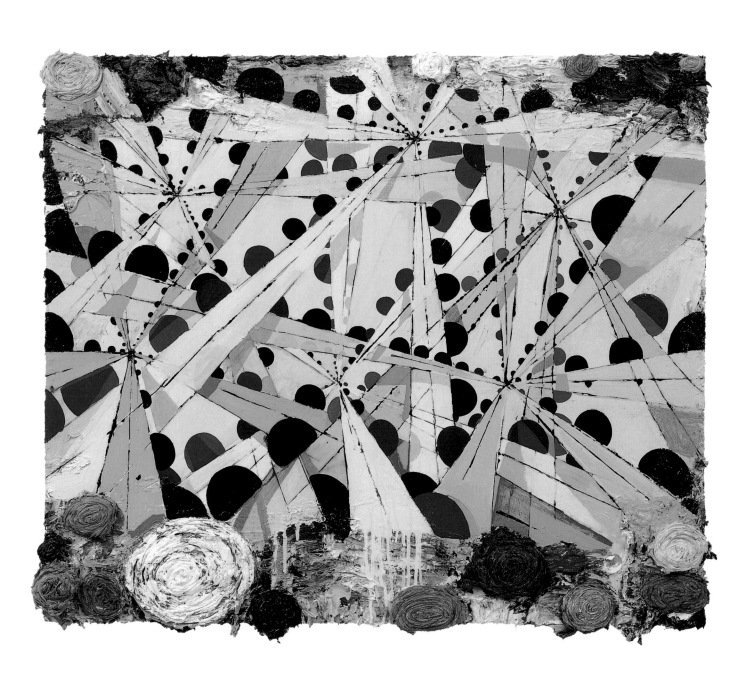

Ponananko 2005

Oil on board 51 × 61 cm

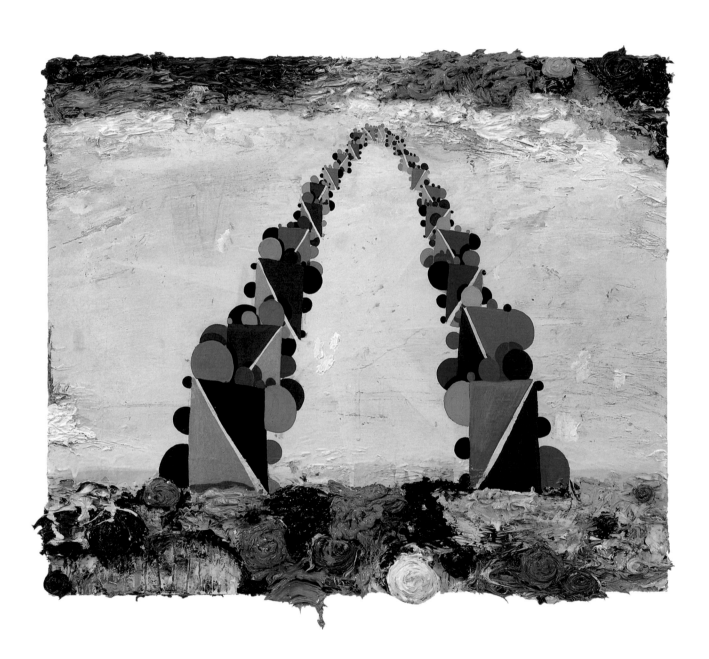

Densequalia (Academy Version) 2005

Oil on board 153 × 183 cm

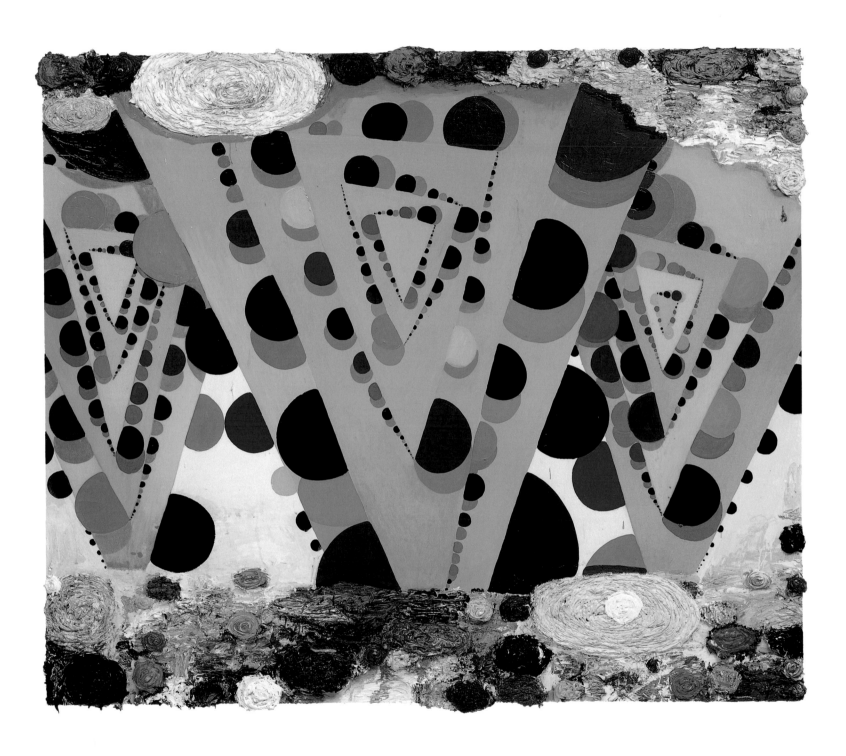

33 (37 Version) 2005

Oil on board 46 × 56 cm

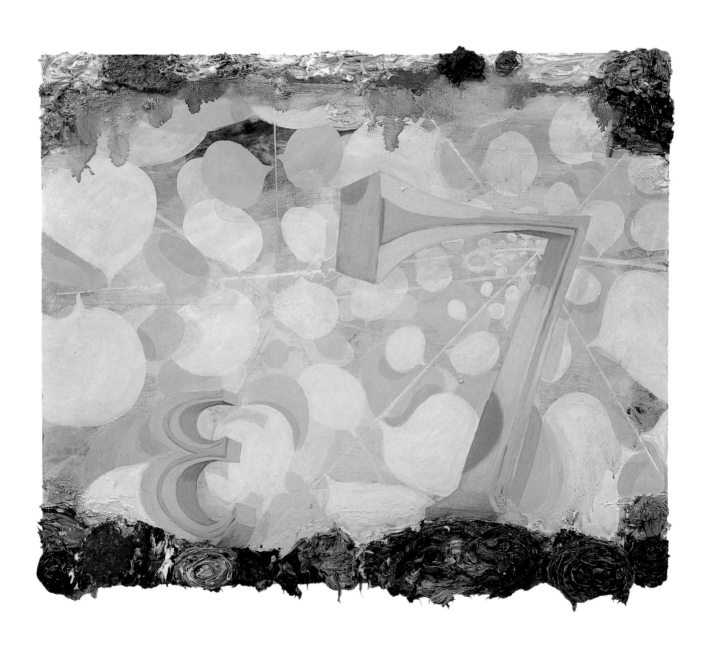

Advanced Variation (Fine Quality Version) 2005

Oil on board 122 × 153 cm

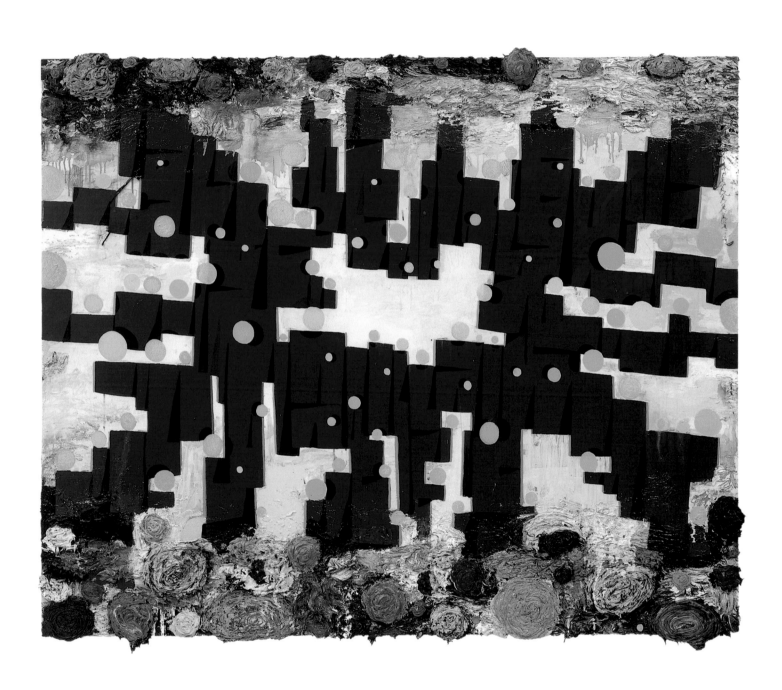

Nollet 2005

Oil on board 46 × 56 cm

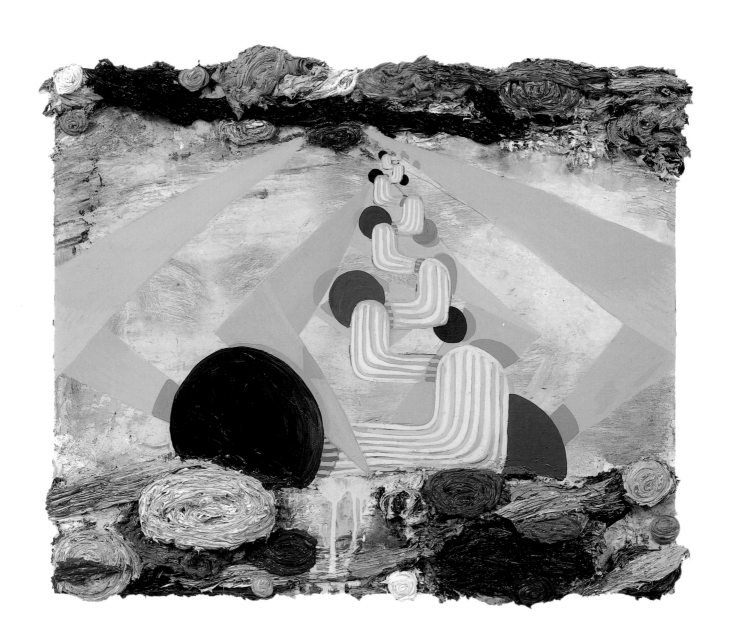

External Avoidance (Small Red Chair Version) 2005

Oil on board 76 × 91 cm

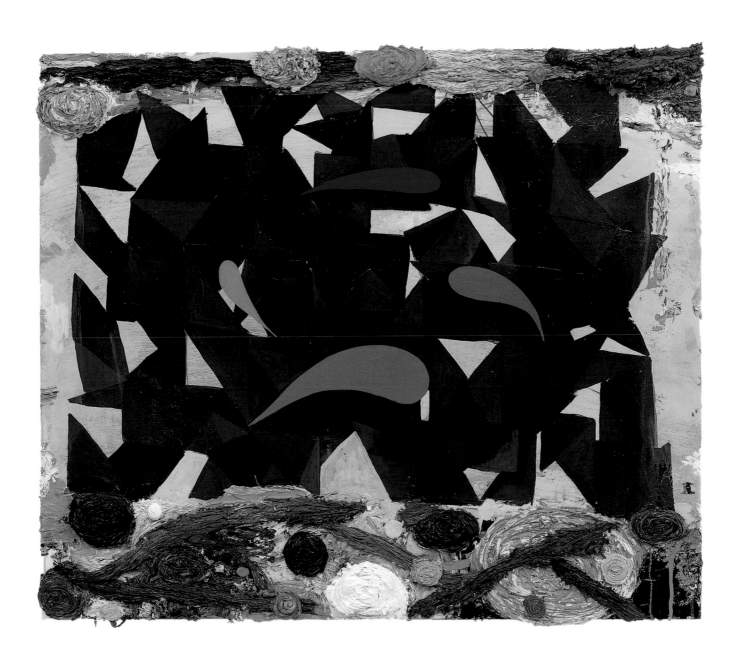

Classic Gambit (Declined Version) 2005

Oil on board 153 × 183 cm

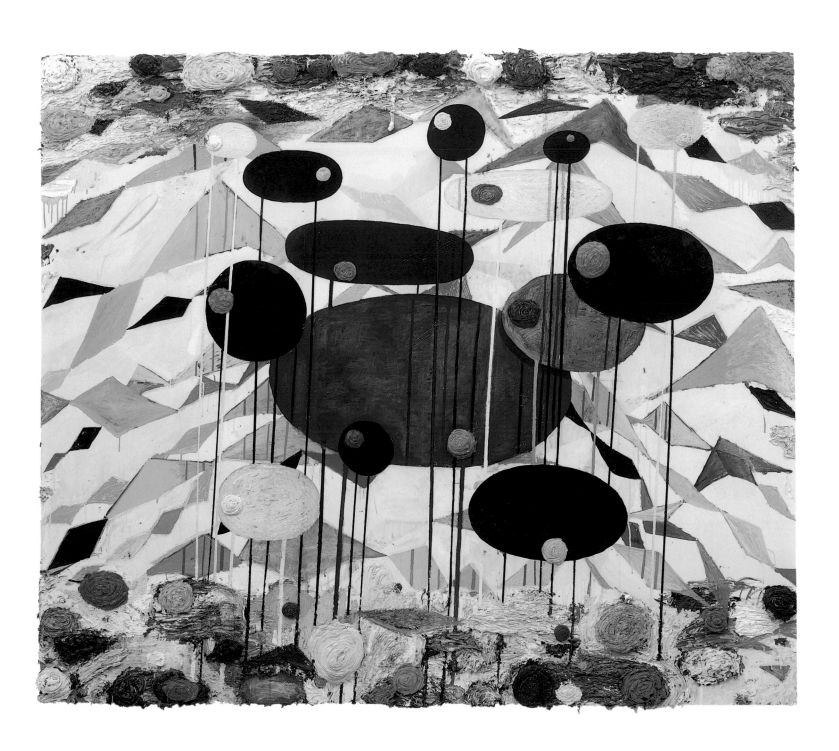

Planning for Purpose (English Version) 2006

Oil on board 40 × 45 cm

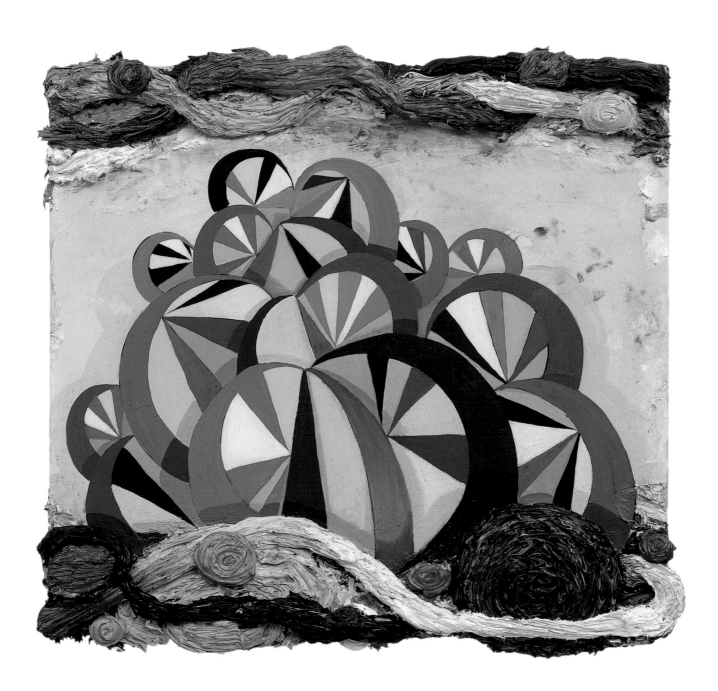

Interzonal Level Sequence (This is Just a Test Version) 2006

Oil on board 183×213 cm

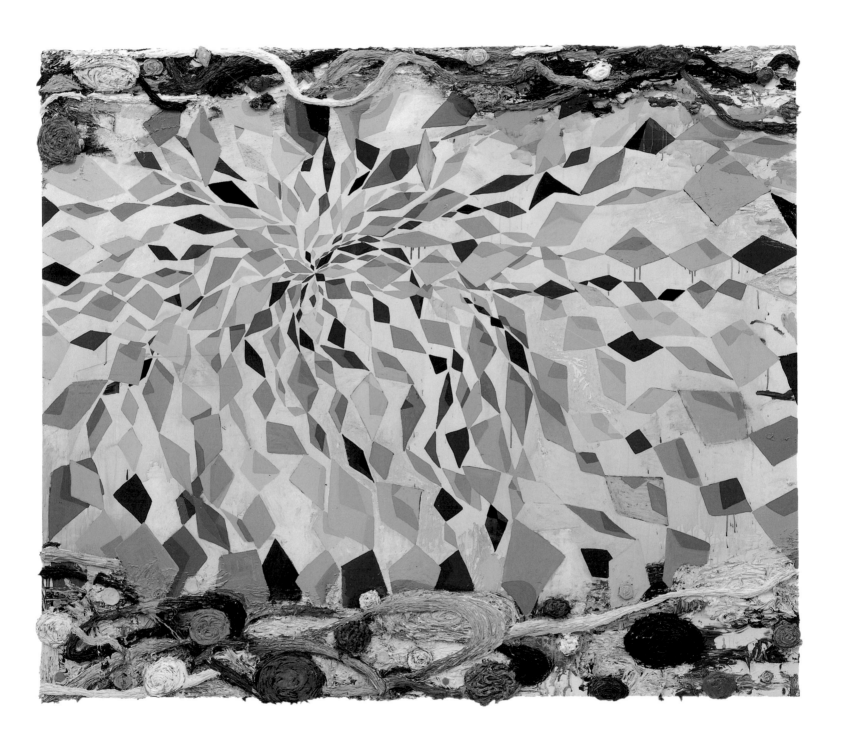

Works

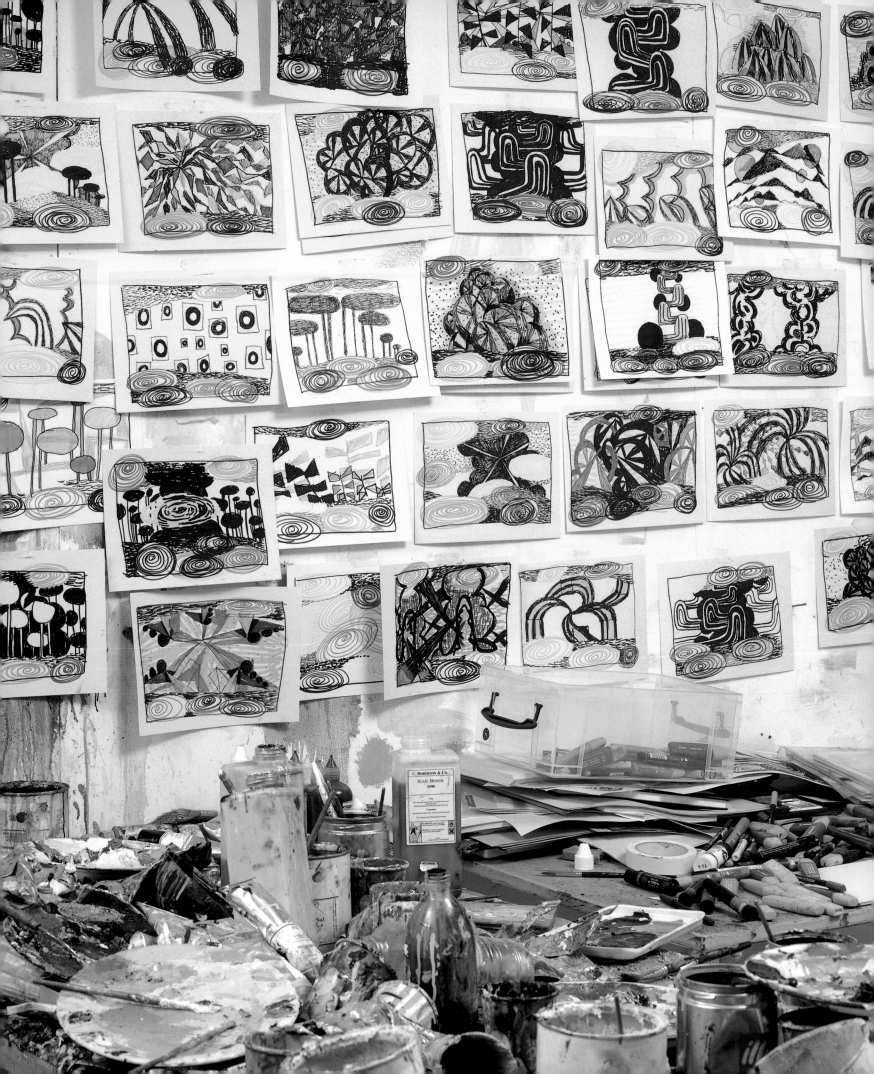

Phillip Allen

Born 1967 in London
Lives and works in London

Education

1990–92 MA Fine Art, Royal College of Art, London
1987–90 BA Fine Art, Kingston University, London

Solo exhibitions

2006 Milton Keynes Gallery, Milton Keynes
2005 Kerlin Gallery, Dublin
One Man Show, Xavier Hufkens, ART Brussels
2004 The Approach, London
2003 Xavier Hufkens, Brussels
Recent Paintings, P.S.1 Contemporary Art Center, Long Island City, New York
2002 The Approach, London
1999 The Approach, London

Group exhibitions

2006 *Archipeinture: painters build architecture*, Frac Île-de-France/Le Plateau, Paris; Camden Arts Centre, London
When forms become attitude, AR/Contemporary Gallery, Milan
2005 *British Art Show 6*, BALTIC Centre for Contemporary Art, Gateshead; venues in Manchester, Nottingham, Bristol (touring exhibition organised by the Hayward Gallery)
Supernova, City Art Gallery, Prague; venues in Vilnius, Lithuania; Tallinn, Estonia; Krakow, Poland (an international touring exhibition organised by the British Council)
Fantasy Island, Metropole Galleries, Folkestone, UK
2004 *Stay Positive*, Marella Arte Contemporanea, Milan
Candyland Zoo, Herbert Read Gallery, Kent Institute of Art and Design, Canterbury, UK
Reflections, Artuatuca Art Festival, Tongeren, Belgium
Painting–04, Kerlin Gallery, Dublin

2003 *Cristian Ward, Phillip Allen, Varda Caivano*, Millefiori Art Space, Athens
Allen, Cooper, McDevitt, Kerlin Gallery, Dublin
Dirty Pictures, The Approach, London
Post Flat: New Art from London, Locks Gallery, Philadelphia
The Drawing Show, Keith Talent Gallery, London
2002 *Another Shitty Day in Paradise*, Bart Wells Institute, London
The Galleries Show: Contemporary Art in London, The Royal Academy of Arts, London
1997 *Cardboard Box and Tape*, Norwich Gallery, Norwich School of Art and Design, Norwich, UK
Still Things, The Approach, London
Multiple Choice, Cubitt Gallery, London
1996 *Grin and Bear It*, Gasworks, London

Bibliography

Publications

2006 *Phillip Allen*, (exh. cat.), Emma Dean and Michael Stanley (eds.), foreword by Michael Stanley, essay by Caoimhín Mac Giolla Léith, Milton Keynes Gallery, Milton Keynes, 2006.
Archipeinture: painters build architecture, (exh. cat.), Anne-Laure Riboulet (ed.), text by Bruce Haines, Frac Île-de-France/Le Plateau, Paris and Camden Arts Centre, London, 2006.
2005 *British Art Show 6*, (exh. cat.), introduction by Alex Farquharson and Andrea Schlieker, Hayward Gallery Publishing, London, 2005, pp. 50–53.
Supernova, (exh. cat.), essay by Caroline Douglas, British Council, 2005, pp. 7–9.
2004 *Stay Positive*, (exh. cat.), preface by Giovanni Marella, Marella Arte Contemporanea, Milan, 2004, pp. 6–9.
Annual 03–04, Martin Clark (ed.), text by Martin Clark, Herbert Read Gallery, Kent Institute of Art and Design, Canterbury, UK, 2004, p. 37, p. 39, p. 43, p. 46, illus.

Reflections, (exh. cat.), texts by Jan Boelen and Hilde Vanleuven, Artuatuca Art Festival, Tongeren, Belgium, 2004.

Articles

2006 Hunt, Andrew, 'British Art (does it) Show?', *Frieze*, no. 96, January/February 2006, pp. 135–137, illus.
2005 Dunne, Aiden, 'Keeping Pace in a Shared Space', *The Irish Times*, 5 October 2005, p. 14.
Leahy, Billy, 'Space to Explore', *The Village*, 16–22 September 2005, p. 61.
McKeith, Elimear, *The Event Guide*, Dublin, 7–20 September 2005.
Ireland's Homes Interiors & Living Magazine, September 2005, p. 161.
2004 Verhagen, Marcus, 'Phillip Allen', *Frieze*, no. 83, May 2004, p. 94.
Hubbard, Sue, 'Phillip Allen: The Approach', *The Independent Review*, March 2004, 30 March, p. 13.
Güner, Fisun, 'An Explosion of Colour', *Metro*, 3 March 2004, p. 22.
2003 Williams, Gilda, 'Dirty Pictures', *Art Monthly*, no. 264, March 2003, p. 32.
Hill, Lori, 'Post Flat: Locks Gallery', *Philadelphia City Paper*, 2–8 January 2003.
2002 Archer, Michael, 'Phillip Allen: The Approach', *Artforum*, vol. XL, no. 9, May 2002, pp. 193–194, illus.
Lack, Jessica, 'Pick of the Week', *The Guide (The Guardian)*, 8–15 April 2002, p. 14.
Geldard, Rebecca, 'Phillip Allen', *Time Out London*, 3–10 April 2002, p. 45.
2000 Smyth, Cherry, 'Nervous Kingdom', *Art Monthly*, no. 238, July/August 2000, p. 41.
1999 Herbert, Martin, 'Phillip Allen', *Time Out London*, 7–14 April 1999, p. 43.

Published on the occasion of the exhibition
Phillip Allen
10 June – 23 July 2006

Image credits
FXP Photography, London: 9, 11, 13, 14, 15,
18–19, 21, 23, 29, 33, 41, 53, 55, 57, 59, 62
Vincent Everarts Photographie, Brussels:
25, 27, 31, 37, 39
Denis Mortell, Dublin: 17, 35, 43, 45, 47, 49
All works © Phillip Allen

MK G, Milton Keynes Gallery
900 Midsummer Boulevard
Central Milton Keynes MK9 3QA
Telephone: +44 (0) 1908 676 900
Fax: +44 (0) 1908 558 308
Email: info@mk-g.org
Website: www.mk-g.org
Registered Charity No. 1059678

Distributed by Cornerhouse Publications
70 Oxford Street, Manchester M1 5NH
Telephone: +44 (0) 161 200 1503
Fax: +44 (0) 161 200 1504
Email: publications@cornerhouse.org
Website: www.cornerhouse.org/publications

ISBN: 0-9544715-9-8

Edited by Emma Dean and Michael Stanley
Designed by Fraser Muggeridge studio
Printing co-ordinated by Uwe Kraus

Phillip Allen and MK G would like to
extend special thanks to: Michael Allen,
Vanessa Carlos, Sicco Deimar, Dr. Edmund
Duffy, Paula Feldman, David Fitzgerald, Peter
& Eloise Goldstein, Linda Grosse, Darragh
Hogan, Ann Hoste, Xavier Hufkens, Jay Jopling,
John Kennedy, Ursula Kennedy, Brian & Rosie
Lowe, Caoimhín Mac Giolla Léith, Mr & Mrs
Jean-Pierre Marchant, Bríd McCarthy, Stephen
McCoubrey, Jake Miller, Lucy Mitchell-Innes,
Donald A. Moore, Emma Robertson, Mario
Testino, Patricia Tsouros, Jeremy Wiltshire

MK G Staff
Kelly Blyth *Gallery Assistant*
Clive Caswell *Gallery Co-ordinator*
Emma Dean *Exhibitions Organiser*
Paul Denton *Press & Marketing Assistant*
Nyla Elahi *Education Assistant*
Lee Farmer *Head of Administration*
Emma Gregory *Gallery Technician*
Emma MacLellan *Head of Development*
Victoria Mayes *Education Co-ordinator*
Kate Parrott *Gallery Assistant*
Giselle Richardson *Press & Marketing Co-ordinator*
Katharine Sorensen *Head of Communications*
Michael Stanley *Director*
Lorraine Stone *Bookkeeper*
Hannah Treherne *Gallery Assistant*
Natalie Walton *Head of Education*
Emma Wilde *Gallery Assistant*
Simon Wright *Gallery Assistant*

MK G Committee
Will Cousins *Deputy Chairman*
Ian Davenport
Graham Ellis
Clive Gear
Christina Grant
John Harper
Martin Holman *Chairman*
Jill Stansfield
Professor John Zarnecki

Milton Keynes Gallery gratefully acknowledges
annual revenue support from Arts Council
England, South East, Milton Keynes Council,
English Partnerships and Milton Keynes Theatre
& Gallery Company.